FINAL FANTASY® XIV
— Picture Book —

THE
Namazu
AND THE
Greatest
Gift

STORY BY **Banri Oda**
(Square Enix)

ART BY **Hiroyuki Nagamine**
(Square Enix)

In the Far, Far East was a great,
grassy steppe, where Namazu
gathered to frolic and feast and
do other things that Namazu do.

The Namazu enjoyed many sunny days on
the steppe. So sunny, in fact, that they soon
found themselves with a big, big problem...

The sun had dried the river right up,
and stolen the fun of fishing!

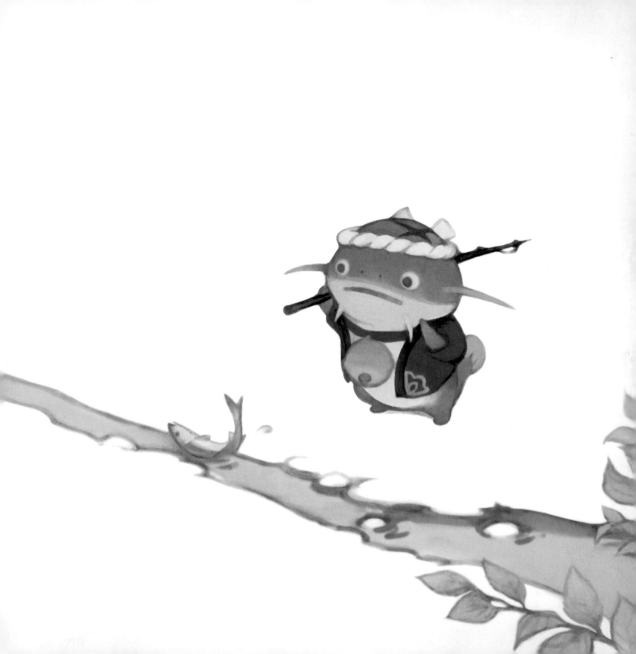

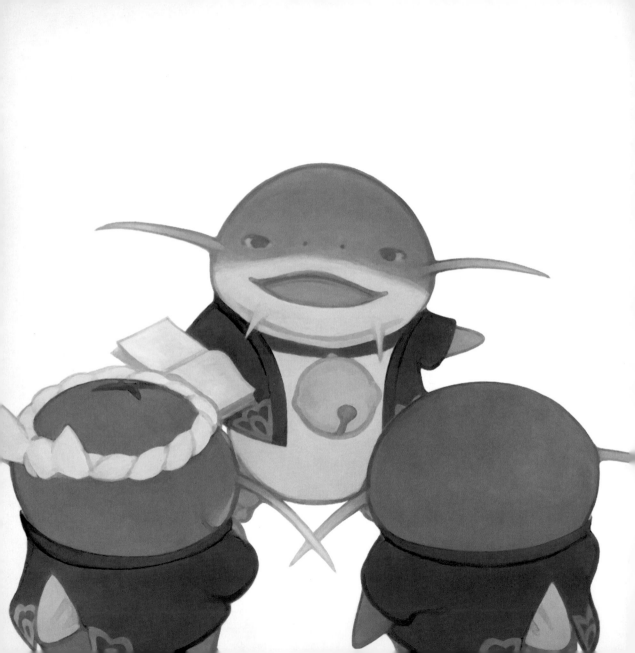

Smelling a chance to seem important, Seigetsu (who thought of many, many things) gathered his friends Gyoshin (who built many, many things) and Gyorei (who was the only one who ever stopped to wonder if those things were a good idea).

"I know a sage who can change the weather," Seigetsu said. "He lives on the mountain beyond the river."

Seigetsu was sure that the sage could solve their problem, so the three Namazu set off to search for him.

After a long, long climb, they found the sage at the top of the mountain.

"You can make it rain, yes, yes?" they asked.

The sage was odd, and his answer was odder.

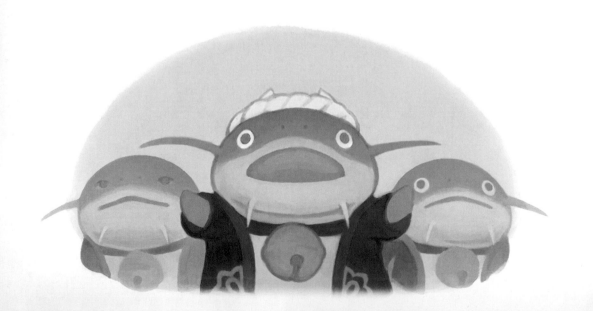

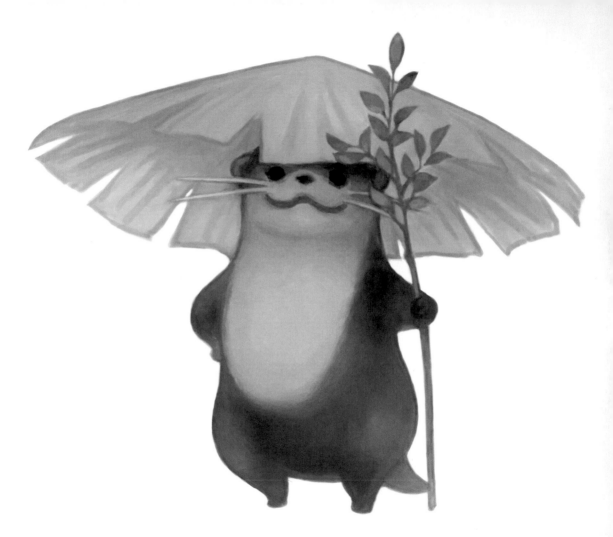

"I can," he said. "Enough to fill your river and more! But I won't. Not unless you find me something new. Something no one has ever seen before."

"Something new? What gift will do?" the three Namazu wondered. They searched through their treasures until each found a present for the sage.

Gyoshin chose a colorful fan from the Namazu's festival.

Seigetsu chose his favorite book, filled with big words.

Gyorei chose a fancy outfit she'd made with her own two fins.

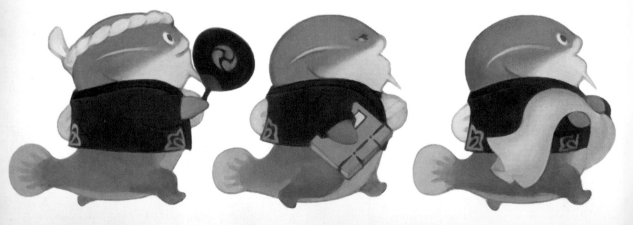

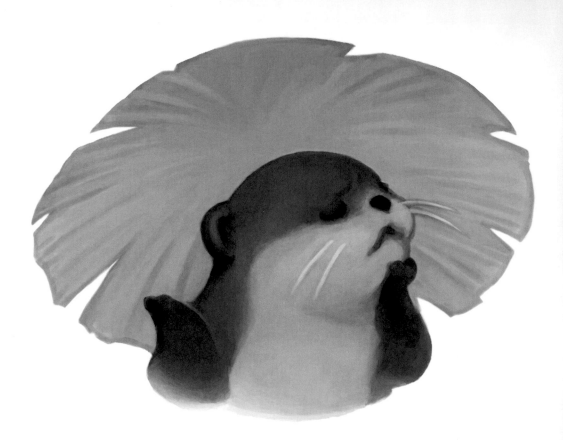

These were all very good gifts, but the sage
would not accept them.

"You've seen these before. They are not new,"
he said, and turned them away.

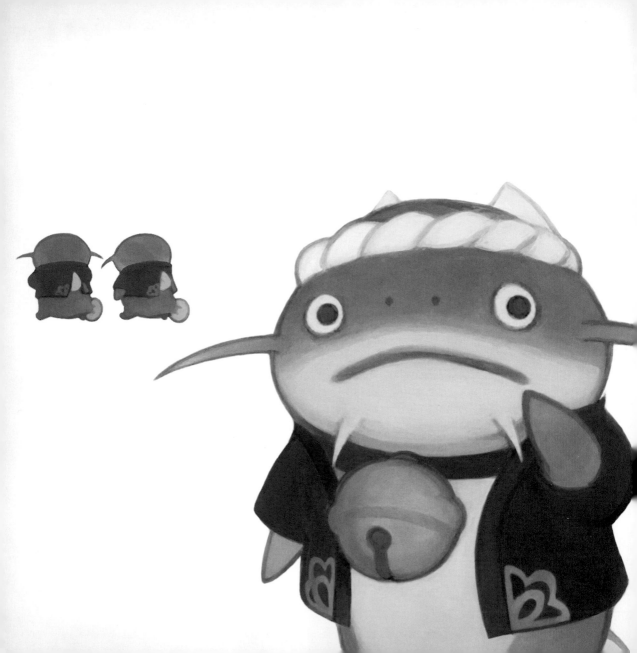

Discouraged, Seigetsu and Gyorei returned to the steppe. If the sage did not want their most treasured treasures, then it was clear that nothing would make him happy.

Gyoshin was not so sure. He stayed behind on the mountain, watching the sage from the shadows.

Gyoshin could find something suitable— a gift to make the sage smile—if only he understood the odd otter a little bit better.

Even though the sage lived all alone at the top of the mountain, he had everything he needed to survive.

When he was hungry, he called the wind to pluck fish from the streams and bring them to his table.

When he was hot, he called the clouds to cover the sun so he could relax in the shade.

Gyoshin was a little bit jealous, actually. Yes, yes.

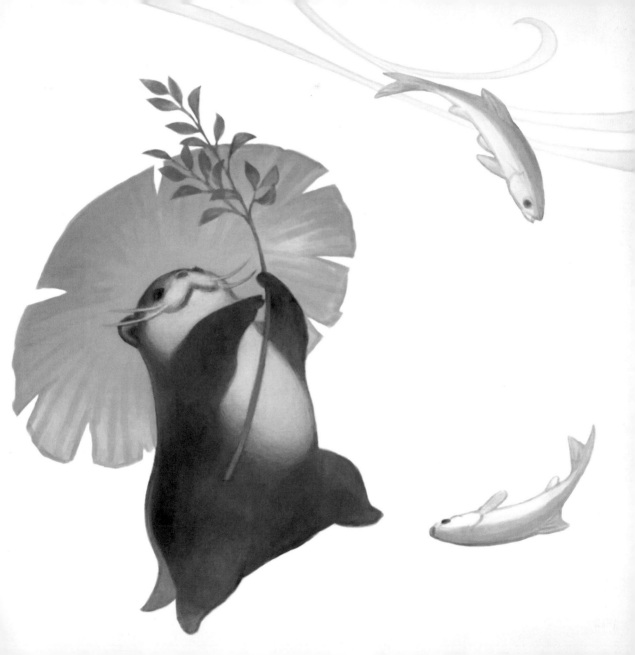

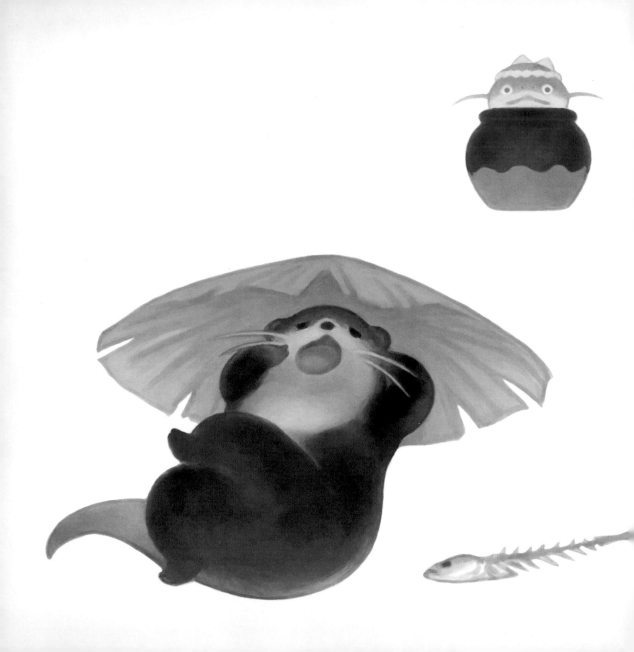

Gyoshin watched for seven days and seven nights. He was starting to think the sage had no problems of any kind.

"Ugh, I am so bored!" the sage said, for the seventh time that day.

What a surprise—how strange! Even with his amazing powers, the sage wasn't having any fun at all, no, no.

It was enough to make a Namazu think, "Hm, hmmm..."

The next day, Gyoshin spoke to the sage again.

"Have you given up?" asked the sage, seeing no gifts in Gyoshin's fins.

"No, no," said Gyoshin. "I have a gift for you. Something so new that no one has ever seen it before! But you must accept it for it to work, because, you see..."

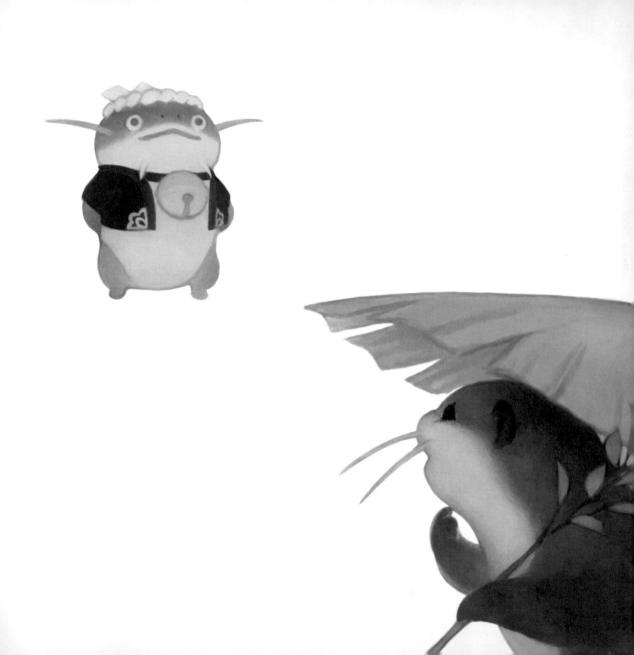

"It's friendship between you and me!

You will accept it, yes, yes?"

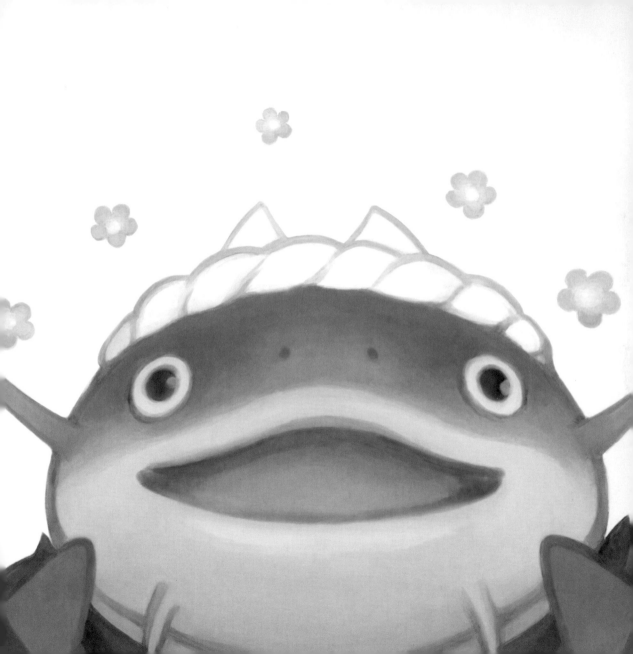

The sage laughed.

"Yes, yes, I suppose I will. No one has ever given me their friendship before."

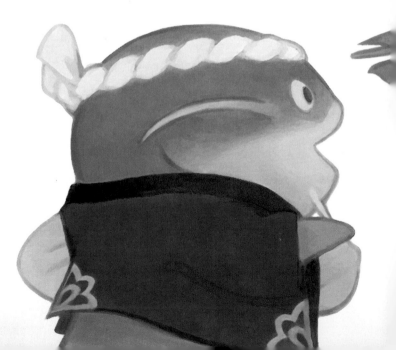

Saying it out loud made the sage realize
how lonely he had been, and how much he
had wanted a friend. Now that he had one,
he was so happy that he cried tears of joy.

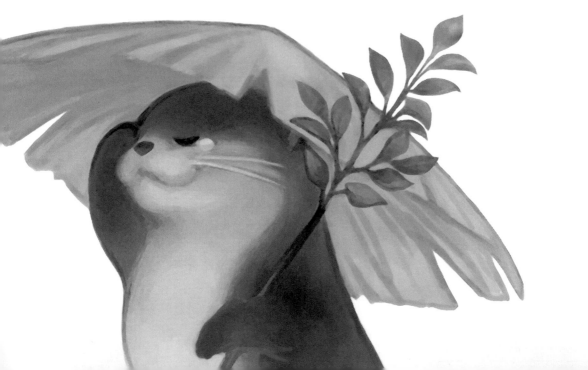

The sage and the Namazu held a ceremony together to call the rains. Soft clouds swept over the steppe as they celebrated together. The raindrops that fell upon them were warm and gentle, and the sage knew he would never feel alone again.

"It is very rainy, most moist indeed!" cried Gyoshin joyfully. "The sky must be happy for us too, yes, yes!"

From that day forward, there was always rain enough on the steppe, and friendship for any who needed it.

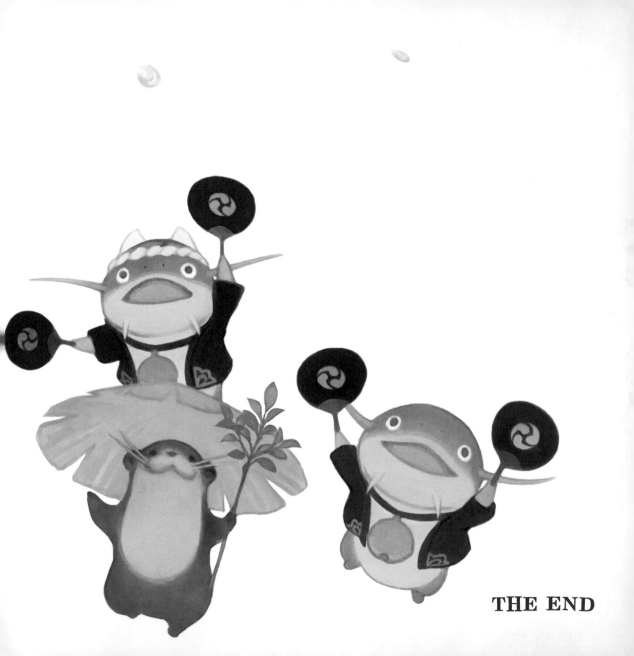

THE END

FINAL FANTASY. XIV
—— Picture Book ——
THE
Namazu
AND THE
Greatest Gift

• **Planning & Production**
Square Enix Co., Ltd.
Editor-in-Chief: Kazuhiro Oya
Editors: Tomoko Hatakeyama, Takuji Tada
Production: Toru Karasawa, Toshihiro Ohoka,
 Tsutomu Sakai

• **Story & Writing**
Square Enix Co., Ltd.
Banri Oda

• **Cover & Interior Art**
Square Enix Co., Ltd.
Hiroyuki Nagamine

• **Design & DTP**
Gaku Watanabe

• **Special Thanks**
Nao Matsuda, Asami Matsumoto
FINAL FANTASY XIV Development Team

• **Supervision**
Square Enix Co., Ltd.
FINAL FANTASY XIV Producer & Director
 Naoki Yoshida

English Edition Translation: FINAL FANTASY
 XIV Localization Team, Kathryn Cwynar,
 Stephen Meyerink
English Edition Design: Adam Grano
English Edition Editing: Leyla Aker

First published in Japan in 2021 by SQUARE ENIX CO., LTD.
English translation © 2022 SQUARE ENIX CO., LTD.
All Rights Reserved. Published in the United States by
Square Enix Books, an imprint of the Book Publishing
Division of SQUARE ENIX, INC.

ISBN: 978-1-64609-144-7

Library of Congress Cataloging-in-Publication
data is on file with the publisher.

Printed in China
First printing, July 2022
10 9 8 7 6 5 4 3 2 1

SQUARE ENIX
BOOKS
www.square-enix-books.com

[North America]
Square Enix, Inc.
999 North Pacific Coast Hwy., 3rd Floor
El Segundo, CA 90245, USA